SIGNIFIKANTE SIGNATUREN
BAND 68

Mit ihrer Katalogedition »Signifikante Signaturen« stellt die Ostdeutsche Sparkassenstiftung in Zusammenarbeit mit ausgewiesenen Kennern der zeitgenössischen Kunst besonders förderungswürdige Künstlerinnen und Künstler aus Brandenburg, Mecklenburg-Vorpommern, Sachsen und Sachsen-Anhalt vor.

In the 'Signifikante Signaturen' catalogue edition, the Ostdeutsche Sparkassenstiftung, East German Savings Banks Foundation, in collaboration with renowned experts in contemporary art, introduces extraordinary artists from the federal states of Brandenburg, Mecklenburg-Western Pomerania, Saxony and Saxony-Anhalt.

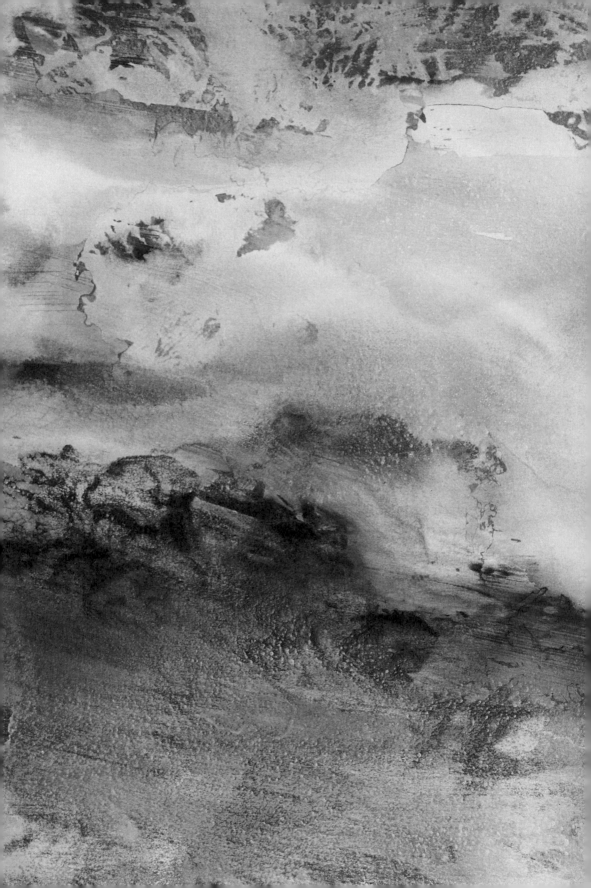

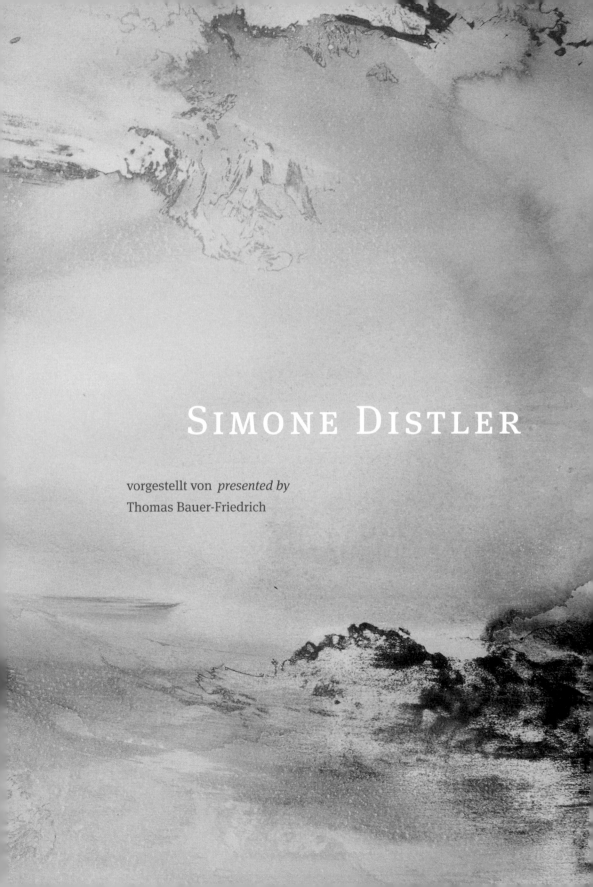

SIMONE DISTLER

vorgestellt von *presented by*
Thomas Bauer-Friedrich

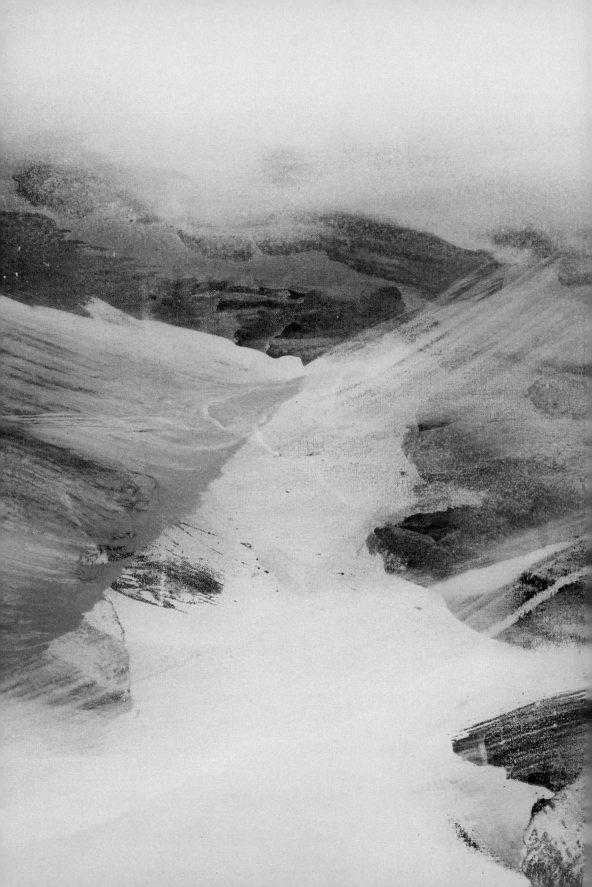

Halt im Haltlosen

Über die Malerei von Simone Distler

Räume von unendlich scheinender Weite gegenüber Mikrostrukturen, als befände man sich in den Gängen eines Höhlensystems oder im Inneren eines Gletschers; zum Stillstand gekommene Aktion gegenüber heftiger Dynamik; kaltes, metallisches Blau oder Grün gegenüber der frühlingshaften Milde von zartem Rosa und aufkeimendem sandigen Gelb ... Diese Gegensatzpaare umreißen die Wirkung, die von den Malereien auf Leinwand oder Papier von Simone Distler ausgeht. Unmittelbar aktivieren sie die Empathie des Betrachters, sodass er sich nur schwer der Kraft, Dynamik und Aktion der Motive entziehen kann, wenngleich sie weder brachial noch aufdringlich auf ihn einwirken – im Gegenteil: Die Werke Simone Distlers eint trotz ihrer motivischen Wucht eine große Ruhe und Stille, die den Betrachter gefangen nimmt, ihn fesselt und im positiven Sinne nötigt, ihrer irritierenden Widersprüchlichkeit nachzugehen.

Da ist zum einen das Motiv selbst. Strukturen erzeugen Räume, die an Landschaften, oft an Gebirgsformationen, mitunter an maritime Situationen erinnern. Doch immer bleiben sie vage, deutungsoffen, unbestimmt. Keines der Motive ließe sich mit einem genauen topographischen Ort in Verbindung bringen. Unwillkürlich stellen sich Assoziationen an Landschaften der Dresdner Romantik ein, von Caspar David Friedrich vor allem, aber auch von Carl Gustav Carus und Johan Christian Clausen Dahl. Wie eine Nachfolge im Geiste entstehen 200 Jahre später von der Hand Simone Distlers landschaftsähnliche Motive, für die der *terminus technicus* der romantischen Landschaftsmalerei, Seelenlandschaft, Lese- oder besser Sehhilfe zu sein vermag: Distler schafft Formationen, die Naturräume assoziieren und sehr konkrete Stimmungen, Emotionen und Einstellungen in uns erwecken. Dennoch rangieren die Motive stets an der Grenze zur Abstraktion; lediglich ihr Aufbau mit einem kompositorischen Zentrum, oft einer horizontähnlichen Linie als strukturgebendes Element und der Suggestion eines Vorn und Hinten aktiviert in uns Erinnerungen an Gesehenes, Erlebtes und bildungsmäßig Erlerntes, woraus wir Landschaftliches konstruieren. Die Künstlerin sagt hierüber: »Was ich sehe, versuche ich einzuordnen und zu fassen, doch wenn ich meine, verstanden zu haben, genau dann differenziert, entzieht oder widerlegt sich mir dieses. Es schiebt sich immer erinnerte Wirklichkeit ins Betrachten, und so wird mir jedes Bild zu einer Denklandschaft.« Gerade deshalb sind Distlers Gemälde Kompositionen, die funktionieren, die in ihrer Abstraktion jeweils eigenen inneren Gesetzmäßigkeiten folgen, sodass sie als vollendet und in sich stimmig erscheinen.

Da ist zum anderen die maltechnische Ausführung der Motive bzw. des auf der Leinwand oder dem Papier materiell Gestaltgewordenen. Immer liegen auf dem Bildträger mehrere Malschichten übereinander, die die Künstlerin in einem mitunter

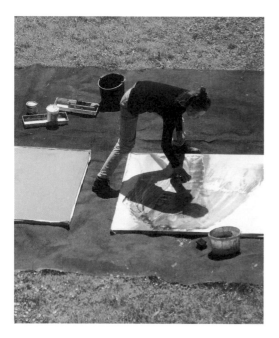

langwierigen Schaffensprozess anlegt. Simone Distler arbeitet intuitiv und doch höchst konzentriert, das Motivwerden bewusst steuernd und beeinflussend. Am Beginn ihrer Arbeit steht eine vage Vorstellung, was auf der vor ihr liegenden, nicht stehenden, Leinwand oder dem Papier Gestalt annehmen könnte – eine noch unbestimmte Ahnung dessen, was die Künstlerin in ihrem Inneren bewegt. Es folgen die ersten Striche mit einem breiten Pinsel, bei den größeren Formaten auch mit einem umfunktionierten Besen. Die Bildträger liegen auf dem Boden vor der Künstlerin oder in einer eigens hierfür von ihr geschaffenen Wannenapparatur. Mit stark verdünnter Acrylfarbe malt sie Bilder, die am Ende wie großformatige Aquarelle anmuten. Sind die ersten Striche und Farbstrukturen gesetzt, füllt sich das Format sukzessive – Zufälligkeiten der Bodenbeschaffenheit oder des spontanen Verlaufens der dünnflüssigen Farbe ausnutzend, diese jederzeit aber auch bewusst lenkend. Nachdem die erste Malschicht getrocknet ist, geht die Künstlerin

an deren Überarbeitung: Partien werden zurückgenommen, mit dem feuchten Schwamm gemildert oder gar ganz ausgekratzt. Andere Partien werden verstärkt, mit neuen Farb- und Malschichten betont, herausgearbeitet, sodass im ständigen Wechselspiel von Auftragen und Abnehmen palimpsestartig allmählich das Motiv entsteht.

Der Malprozess Simone Distlers erinnert an die asiatische Tuschemalerei, die sie nach eigenen Aussagen fasziniert und beeinflusst hat. Meditative Konzentration und spontane Intuition kennzeichnen auch hier die Entstehung der Werke. Und so, wie vor einem halben Jahrhundert Künstler wie K.O. Götz (geb. 1914) in Auseinandersetzung mit der asiatischen Kunst zu einem neuen Ausdruck – dem Informel – gelangten, so sind auch die Schöpfungen der deutschen Informellen Götz, Emil Schumacher (1912 – 1999) oder Fred Thieler (1916 – 1999) die geistig-künstlerischen Paten Simone Distlers. Deren wie ihre Arbeiten kennzeichnet eine große Dynamik des Arbeitens und somit des Dargestellten. Energie, Bewegung, mitunter gegenläufig wirkende Kräfte, resultierend aus dem gestischen Arbeiten, charakterisieren maltechnisch die Werke Simone Distlers und erzeugen im Reibungsprozess mit den Motiven die eingangs beschriebene verschiedenartige Wirkung ihrer Malereien. Die Künstlerin selbst sagt hierzu: »Im Bild suche ich zum Teil genau diese Erfahrung, den Moment, der die Bequemlichkeit durchbricht, der meine Kontrolle in Frage stellt und den Blick erweitert.«

Das hier Beschriebene berechtigt zu der Annahme, dass die junge Malerin auf einem langen Weg der künstlerischen Selbstfindung nunmehr zu der mittels der in diesem Band zusammengestellten Arbeiten repräsentierten Bildsprache gelangte. Dieser Schluss ist falsch! Simone Distler ist, wie sie selbst von sich sagt, eine »Spätstarterin«. Nach ihrer schulischen und beruflichen Ausbildung arbei-

tete sie zunächst einige Jahre in der Modebranche. Während dieser Zeit wurde sie sich bewusst, dass es sie zum eigenen freien kreativen Arbeiten drängt und dazu, das Erlebte, äußere und innere Welten, auszudrücken und zu verarbeiten. So nahm sie 2009 das Studium an der Burg Giebichenstein Kunsthochschule Halle auf, der traditionsreichen Kunsthochschule des Landes Sachsen-Anhalt im namensgebenden Komplex der mittelalterlichen Burg Giebichenstein hoch über der Saale im Norden der Stadt Halle (Saale). Während ihres Studiums bei Professor Ute Pleuger suchte sie zunächst nach dem ihr eigenen Thema und den adäquaten Motiven. Waren diese anfänglich noch gegenständlich nachahmend am Natureindruck orientiert, fand sie um 2013 zu jener Bildsprache, die ihr Schaffen bis heute kennzeichnet. Im Anschluss daran begab sie sich 2013/14 in Vorbereitung ihres Diploms auf eine intensive Auseinandersetzung mit maltechnischen Fragen und auf die Suche nach der geeigneten technischen Umsetzung ihrer Bildsprache. Dies führte sie zu den hier präsentierten Malereien auf Leinwand und Papier im großen Format von bis zu zwei Metern. Einen Ausschnitt der auf diese Weise in den zurückliegenden zwei Jahren entstandenen Malereien stellt die Auswahl des vorliegenden Bandes vor.

»Landschaft als Anlass für Malerei: Neu ist dieses Konzept nicht. Auch Kompositionen, die wie ferne Erinnerungen an Naturwahrnehmungen anmuten, können in der zeitgenössischen Kunst nicht mehr als neu und unbekannt gelten«, urteilte die FAZ am 27. Mai 2004 in einer Ausstellungsrezension über den in Köln lebenden Maler Thomas Kohl. Wenn auch nicht radikal neu und unbekannt, so doch aber eine neue, des Bemerkens werte Facette zeitgenössischen malerischen Schaffens sind die Werke Simone Distlers, für die »Landschaft als Anlass« nur insofern gilt, als dass am Beginn des kreativen Prozesses durchaus eine landschaftliche An-

regung aus dem Naturerleben der Künstlerin steht, und zwar aus dem andernorts Abgespeicherten heraus, denn mit den Landschaften ihrer sachsen-anhaltischen Wahlheimat haben ihre Motive nichts gemein. Die Künstlerin befreit sich unverzüglich von der reinen Landschaftsdarstellung und stellt im weiteren Schaffensprozess die ewig gültigen künstlerischen Fragen nach kompositorischer und gestalterischer Ausgewogenheit. Es ist die Suche nach Halt im Haltlosen, die die Künstlerin umtreibt, womit ihre Werke, die auf den ersten Blick vermeintlich wenig mit unserer täglich erlebten Realität zu tun haben, die sie umgebende Umwelt reflektieren und bildkünstlerisch verarbeiten.

Wie eingangs skizziert, kennzeichnet Simone Distlers Arbeiten eine besondere Charakteristik hinsichtlich des Dreiklangs aus Komposition, farblicher Gestaltung und Bildwirkung: Die endlose Weite eines transparenten, flüchtigen Bildraums, in der sich der Blick des Betrachters zu verlieren droht, wird eingefangen durch massive, dunklere Strukturen, die Halte- und Orientierungspunkte darstellen; die Kühle und Unwirtlichkeit der Motive in ihrer blau-grünen Grundtonalität wird kontrastierend aufgewärmt durch gelbliche und rosafarbene Töne, und schließlich bändigt auf diese Weise die Gesamtstruktur die dynamische Gestik des Farbauftrags. Alles Haltlose, sich Verflüchtigende wird eingefangen, gebändigt und gehalten, sodass wir in den weiten kühlen Welten der Gemälde nicht verlustig zu gehen drohen. Darin liegen die Zeitbezogenheit und die besondere Qualität der abstrakten Landschaften Simone Distlers begründet.

Thomas Bauer-Friedrich

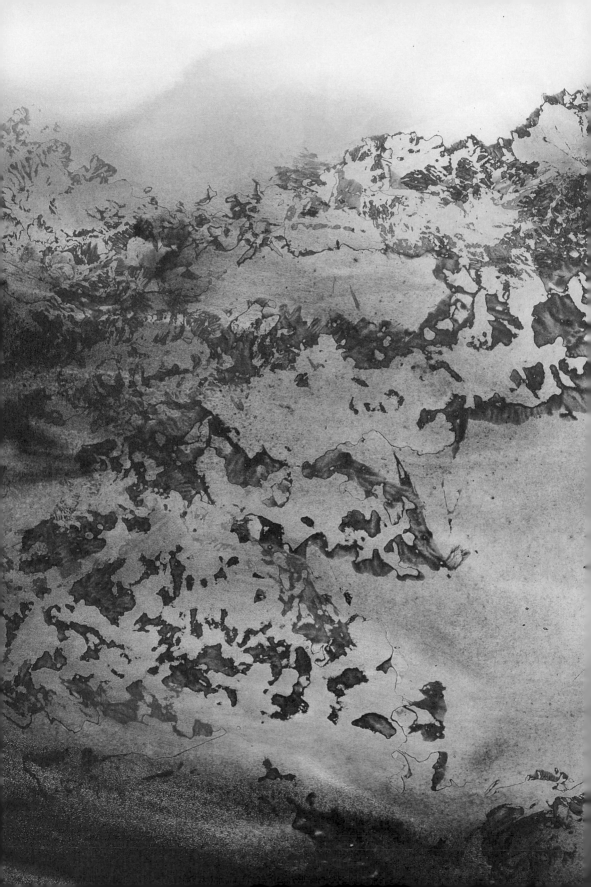

STABILITY IN INSTABILITY

ON THE PAINTINGS OF SIMONE DISTLER

*E*xpanses of seemingly endless space contrasting with microstructures – as if in the passages of a cave system or the interior of a glacier; suspended action contrasting with vigorous dynamism; cold, metallic blue or green standing out against the vernal softness of delicate pink and burgeoning sandy yellow… These contrasting pairs encapsulate the effect that emanates from the paintings on canvas or paper by Simone Distler. They directly stimulate the empathy of the viewer, making it difficult for him to elude the power, dynamism and action of the motifs, even if their impact on him is neither brutal nor obtrusive – on the contrary: despite the vehemence of their motifs, Simone Distler's works share a great tranquillity and calm that captivates the viewer, mesmerising him and urging him, in a positive way, to scrutinise their disturbing contradictoriness.

For one thing, there are the motifs themselves. Structures create spaces that are reminiscent of landscapes, often mountain formations, sometimes maritime scenes. And yet they always remain vague, open to interpretation, undefined. None of the motifs could ever be related to any precise topographical location. Associations are spontaneously evoked with landscapes by Dresden painters of the Romantic period, particularly the works of Caspar David Friedrich, but also those of Carl Gustav Carus and Johan Christian Clausen Dahl. As if picking up a spiritual legacy some 200 years after these artists, Simone Distler now creates landscape-like motifs for which the defining term of Romantic landscape painting, that of the 'land-

scape of the soul', can help us to read, and indeed view, her works: Distler creates formations that conjure up associations with natural spaces and evoke very specific moods, emotions and attitudes in us. Nevertheless, the motifs constantly hover on the boundary of abstraction; it is only their structure with a compositional centre, often a horizon-like line as a structure-providing element, and the suggestion of a foreground and background, that arouses memories of things we have seen, experienced and learnt through education, causing us to mentally construct a landscape. The artist says of this, "Whatever I see, I try to categorise and grasp, but just when I think I have understood, it eludes or evades me, or proves me wrong. When looking, remembered reality constantly interposes itself, so that, for me, every image turns into a thought landscape." For exactly this reason, Distler's paintings are compositions that work, that – in their abstraction – each follow their own internal laws, so that they appear complete and coherent.

For another thing, there is the artistic execution of the motifs, or of that which has taken material form on the canvas or paper. There are always several layers of paint on the support, each of which is carefully laid down by the artist in a laborious creative process. Simone Distler works intuitively yet with great concentration, consciously controlling and influencing the development of the motif. Her work begins with a vague notion of what might take shape on the canvas or paper lying, not standing, before her – an as yet undefined concept of what moves the artist

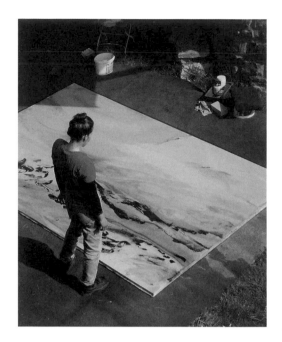

The painting process used by Simone Distler is reminiscent of Asian ink painting, which she herself says she finds fascinating and which has influenced her work. There too, the creation of works of art is characterised by meditative concentration and spontaneous intuition. Hence, just as artists like K.O. Götz (born 1914) developed a new form of artistic expression — l'art informel — through active engagement with Asian art half a century ago, the creations made by the German Informel artists Götz, Emil Schumacher (1912 – 1999) and Fred Thieler (1916 – 1999) can be regarded as the intellectual and artistic mentors behind Simone Distler. Their works, like hers, are characterised by great dynamism in the working process and in that which is represented. Energy, movement and sometimes opposing forces, which result from a gestural manner of working, are a hallmark of Simone Distler's works as regards her painting technique; and the process of friction between these forces and the motifs gives rise to the diverse effects of her paintings, as described above. The artist herself says, "In my pictures I am sometimes seeking precisely this experience – the moment which shakes me out of my complacency, which calls my control into question and expands my perspective."

deep inside. This is followed by the first strokes using a broad brush or, in the case of the large-scale formats, even a converted broom. The supports lie on the ground in front of the artist or in a kind of trough created by the artist specifically for this purpose. Using heavily diluted acrylic paint, she creates images that ultimately resemble large-format watercolours. After placing the initial strokes and colour structures, the surface is gradually filled in – taking advantage of chance irregularities in the surface or the spontaneous dispersal of the thin paint, whilst always consciously guiding the process. Once the first paint layer has dried, the artist sets about reworking it: certain areas are undone, tempered with a damp sponge or even completely scratched off. Other areas are intensified, given emphasis with new layers of paint, or worked in more detail, so that the motif gradually comes into being through a constant interplay between application and removal in the manner of a palimpsest.

What she describes here might justify the assumption that this young painter arrived at the pictorial vocabulary represented through the works included in this volume through a long process of artistic self-discovery. That assumption would be wrong! Simone Distler is, as she says of herself, a "late starter". After finishing school and completing her vocational training, she initially worked for several years in the fashion industry. During this time she became aware of a strong desire to produce her own, independent creative work and to express and explore her experiences, external and internal worlds. And so in 2009 she began studying at the Burg Giebichenstein Kunst-

hochschule Halle, the long-standing art academy of the federal-state of Saxony-Anhalt located in the complex of buildings that make up the medieval castle of Burg Giebichenstein high above the River Saale to the north of the city centre of Halle (Saale). During her course of studies under Professor Ute Pleuger, she initially searched for a theme of her own and for suitable motifs. Whereas at first these were still representational, based on impressions of nature, around 2013 she developed the form of pictorial expression that continues to characterise her works today. After that, while preparing for her Diplom (equivalent to a Master's degree) in 2013/14, she set out on an intensive exploration of painting techniques, seeking the most suitable way of putting her visual vocabulary into effect. This led to the production of these paintings on canvas and paper in a large format of up to two metres. The selection of works included in this volume represents an excerpt from the paintings produced in this way over the past two years.

"Landscape as an inspiration for painting: this concept is nothing new. Compositions that seem like distant memories of perceptions of nature are also not something that can be regarded as new and unfamiliar in contemporary art," noted the newspaper Frankfurter Allgemeine Zeitung on 27 May 2004 in a review about an exhibition by the Cologne-based artist Thomas Kohl. Even if they are not radically new and unfamiliar, a new, remarkable facet of contemporary painting is nevertheless presented by the works of Simone Distler, for which "landscape as an inspiration" only applies insofar as there is an initial impulse from the artist's experience of nature at the beginning of the creative process, albeit one that is stored elsewhere, since her motifs have nothing in common with the landscapes of her adopted homeland of Saxony-Anhalt. The artist immediately liberates herself from the pure representation of landscape, and in her ongoing creative process she explores the eternal artistic issues of compositional and creative balance. It is a search for stability in instability that motivates the artist, so that her works, which at first glance seem to have little to do with our day-to-day experience of reality, are reflections and artistic responses to the world around her.

As outlined at the beginning, Simone Distler's works are characterised by a special triad consisting of composition, colour and pictorial effect: the endless expanse of a transparent, fleeting image space, in which the viewer's gaze threatens to be dissipated, is captured through massive, darker structures that provide points of stability and orientation; the coolness and inhospitality of the motifs, with their basic tone of bluish green, is warmed up by contrasting yellow and pink hues, and thus the overall structure tames the dynamic gestural effect of the way in which the paint has been applied. Everything that is unstable and fleeting is captured, tamed and subdued, so that we do not run the risk of being lost in the vast cool worlds of these paintings. It is this that accounts for the time-bound nature and the exceptional quality of the abstract landscapes of Simone Distler.

Thomas Bauer-Friedrich

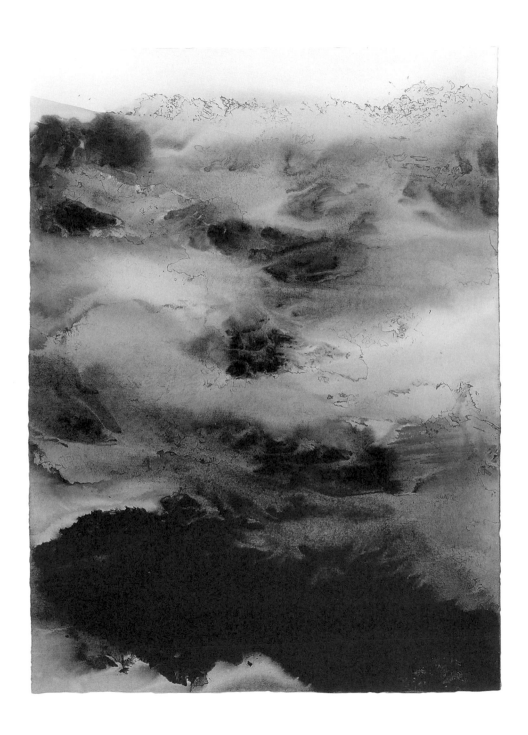

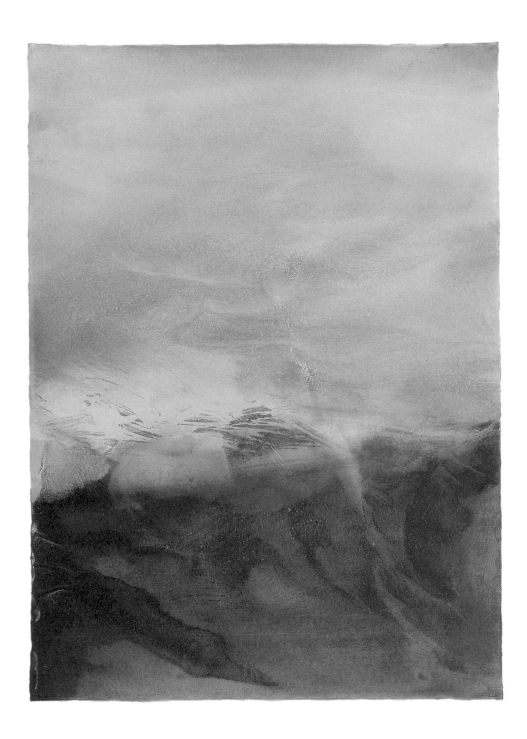

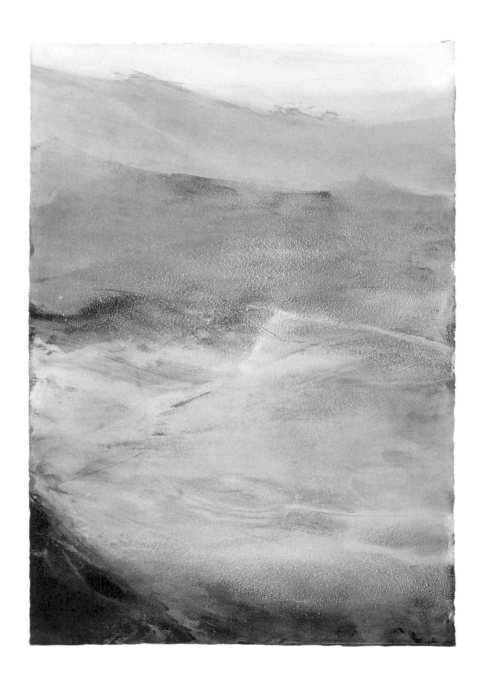

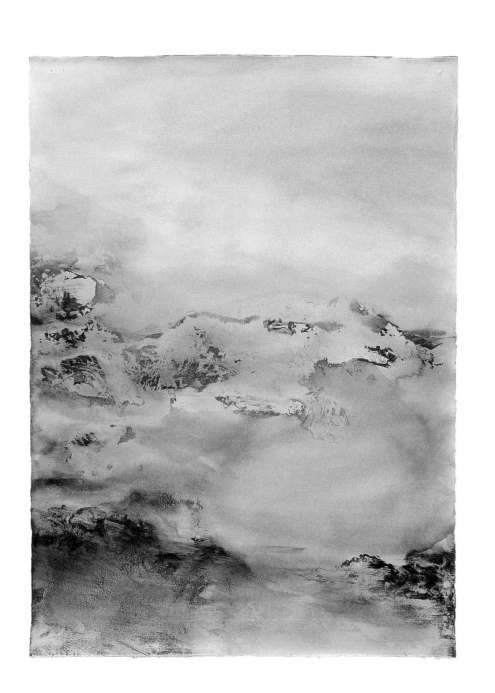

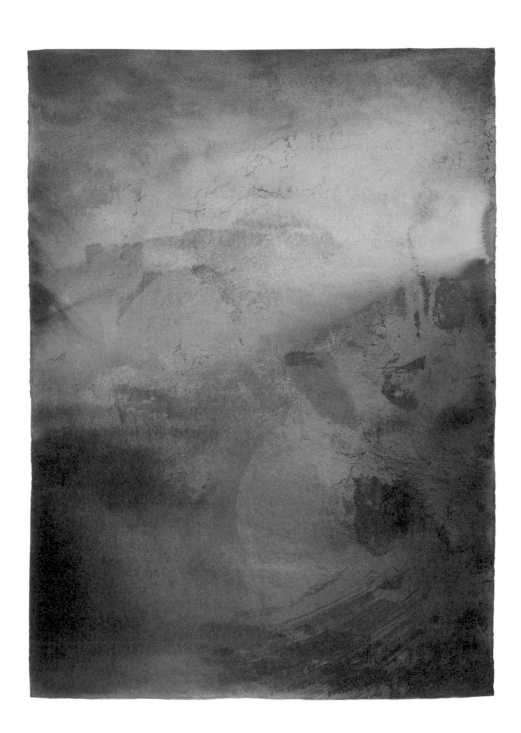

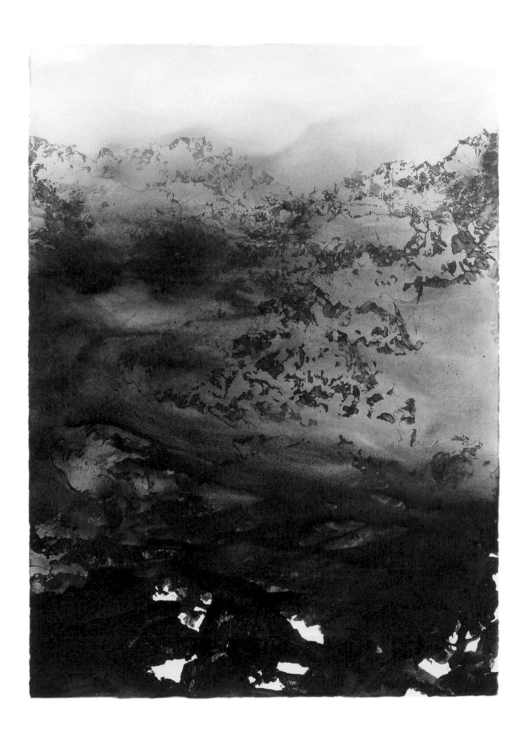

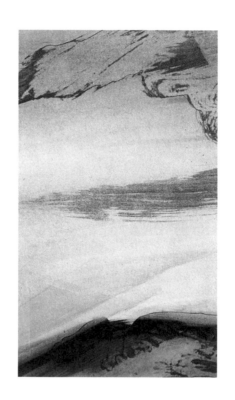

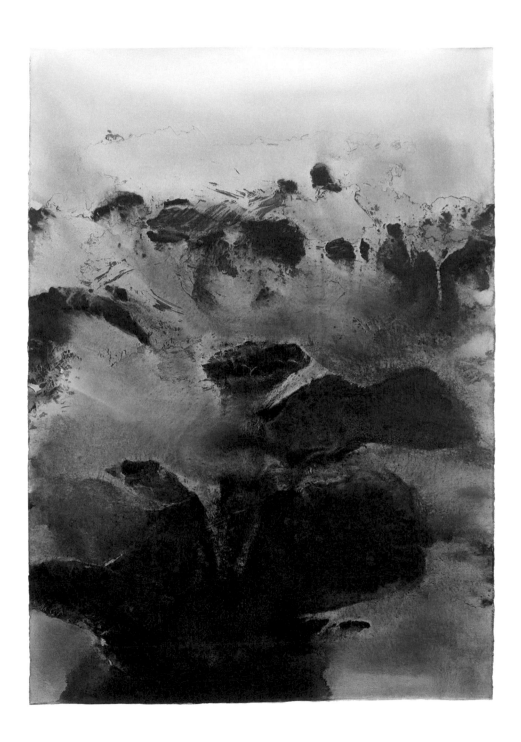

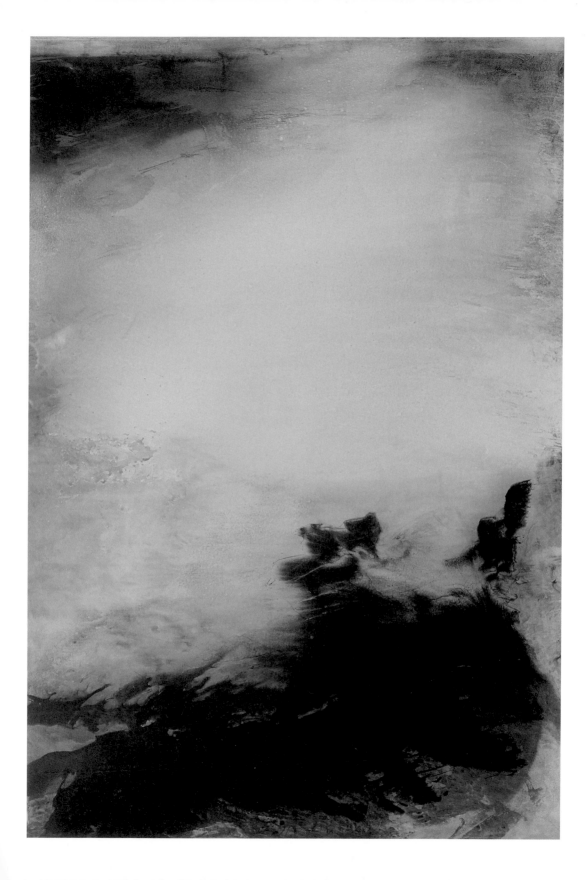

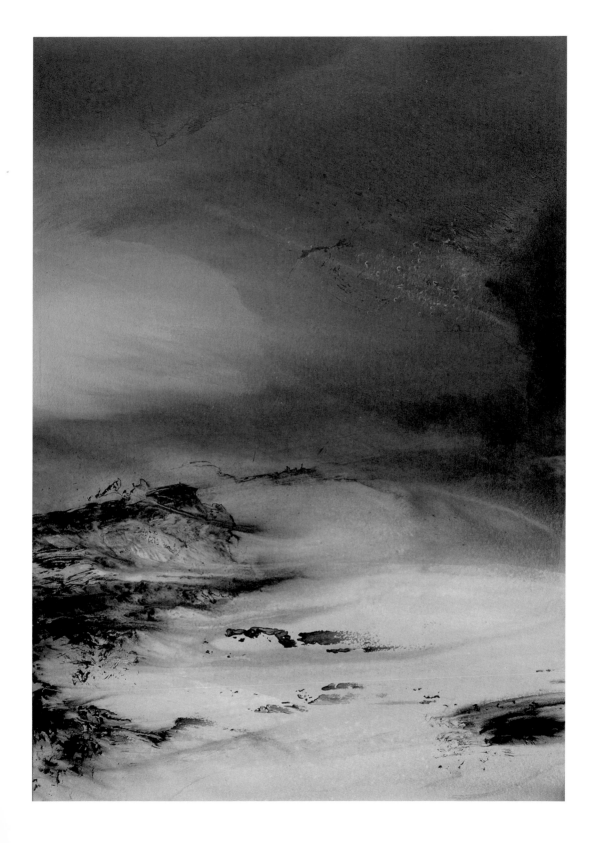

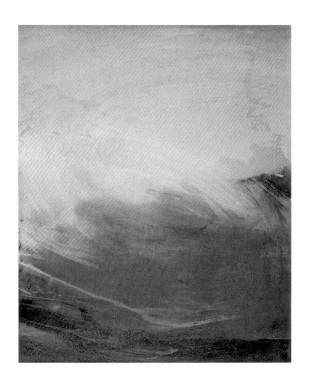

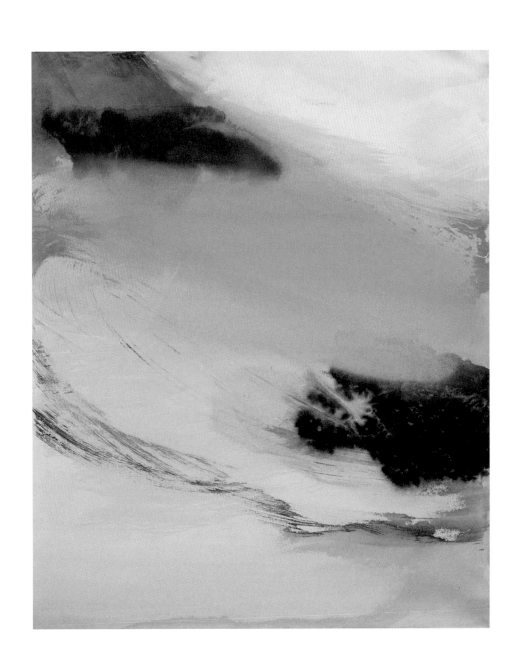

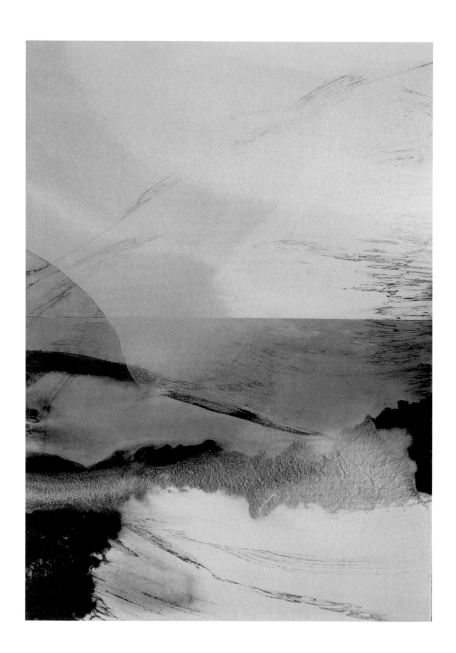

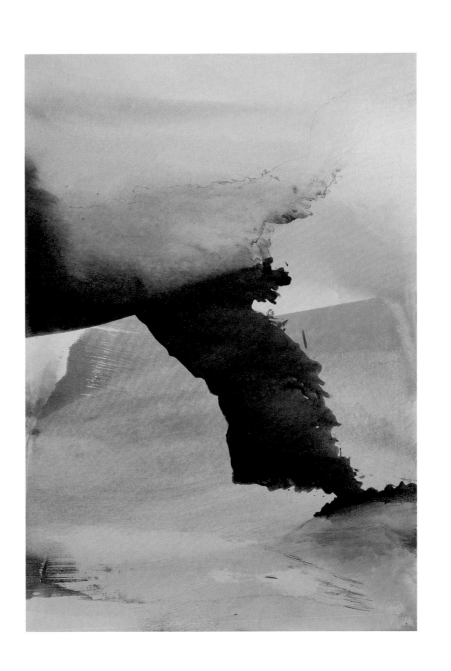

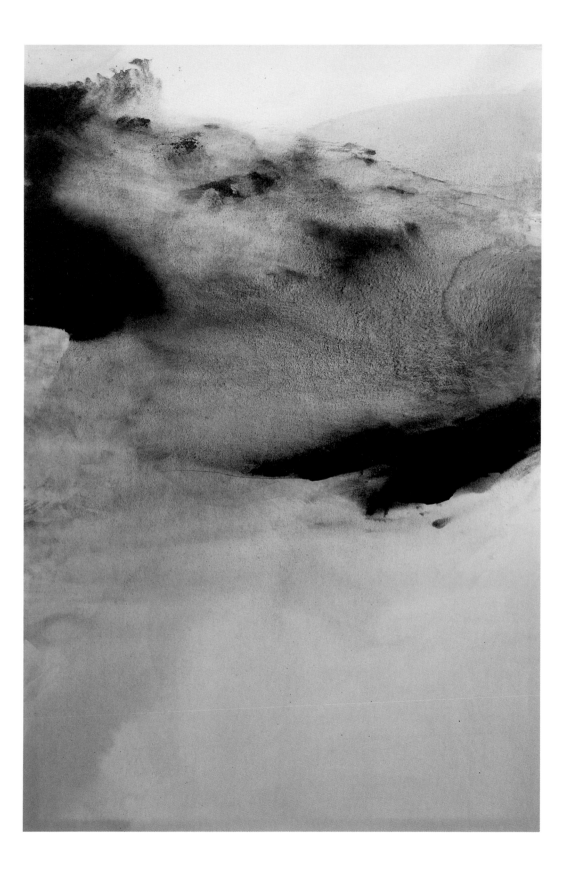

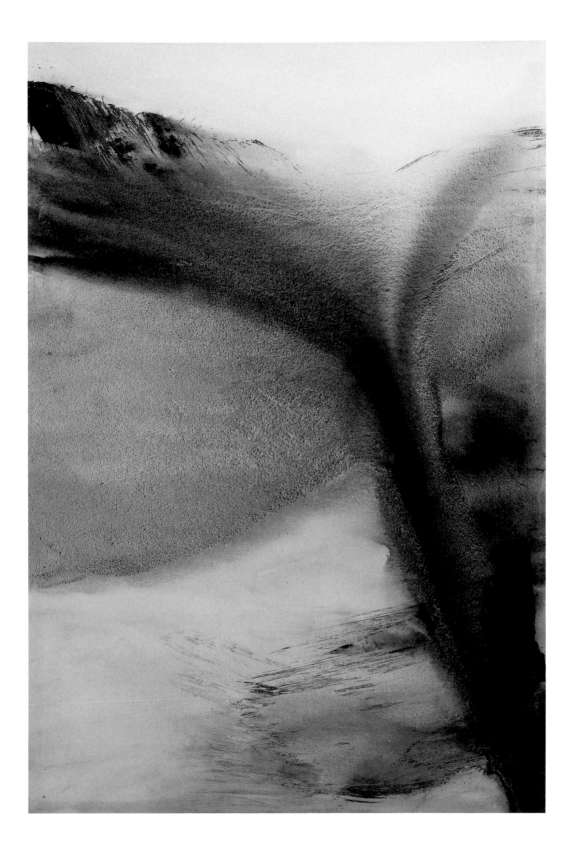

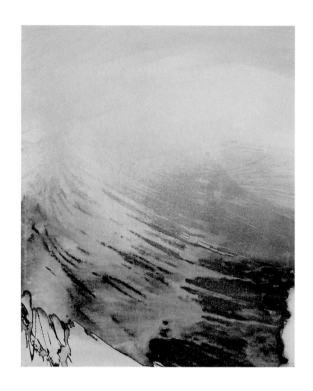

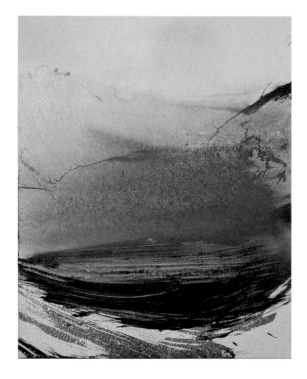

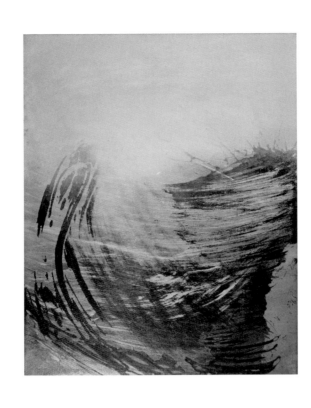

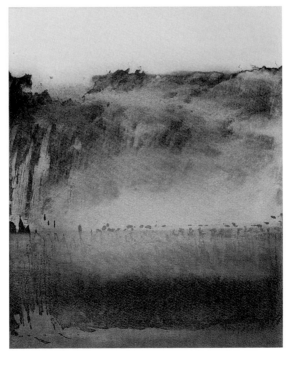

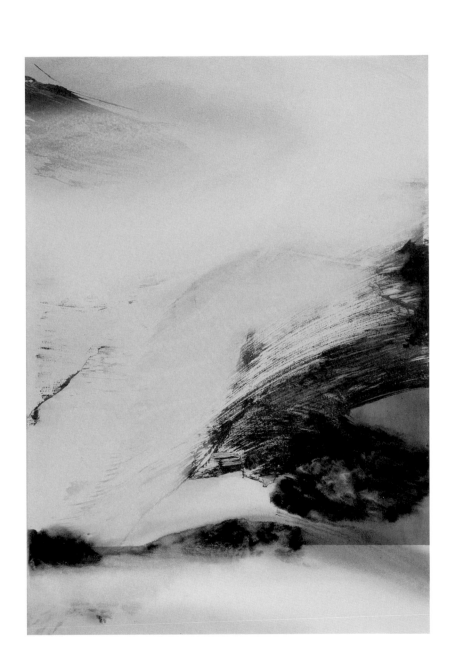

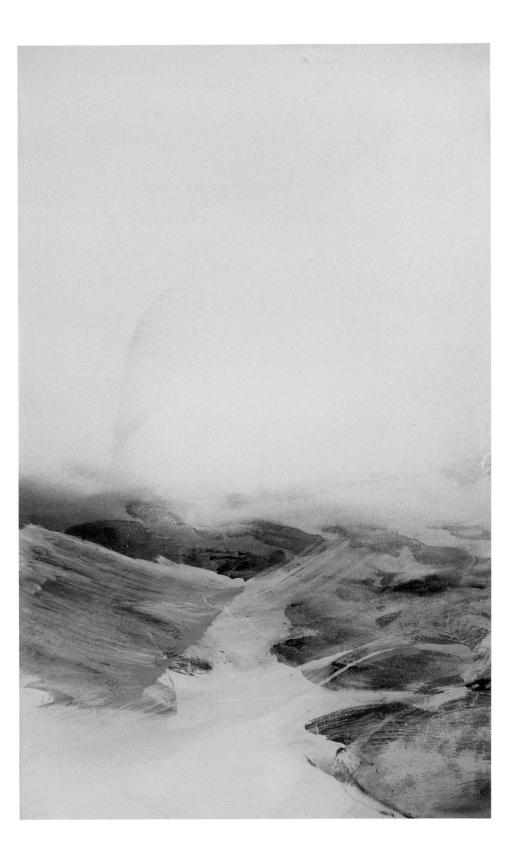

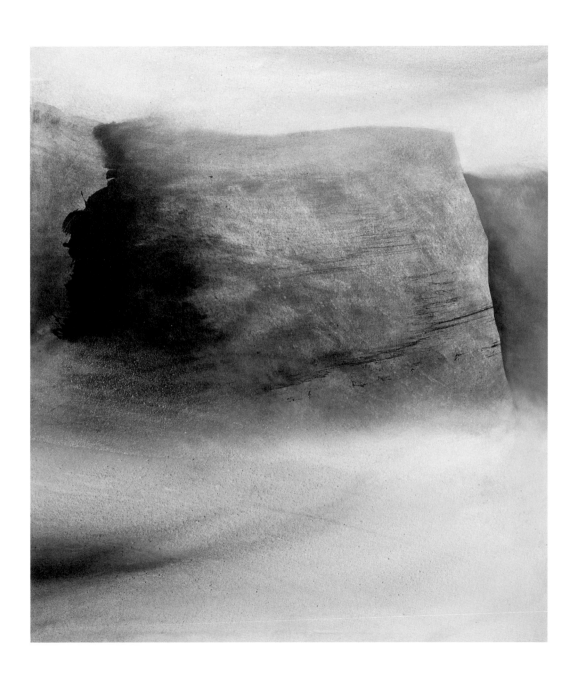

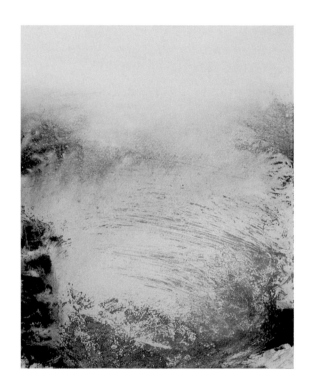

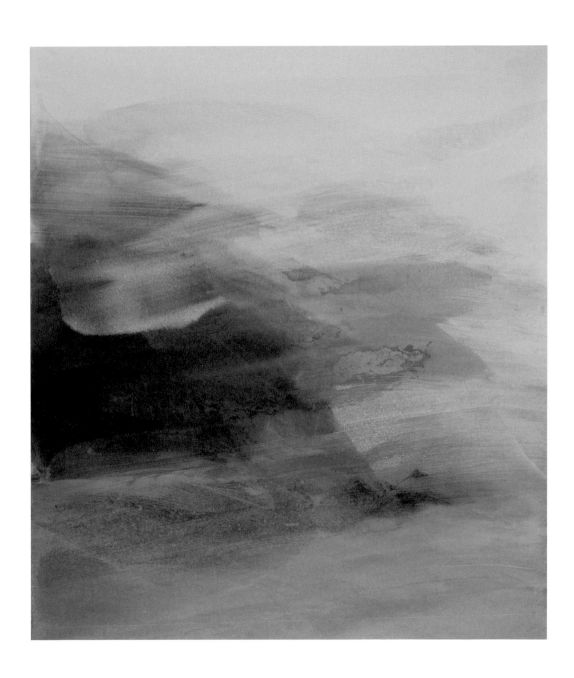

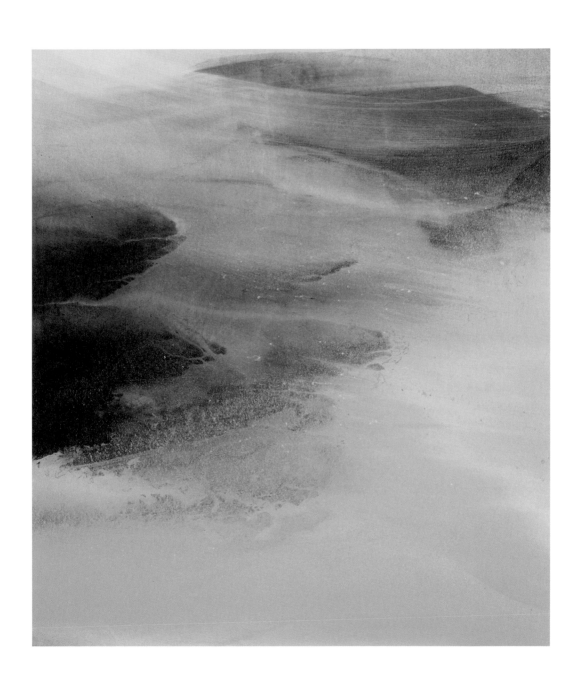

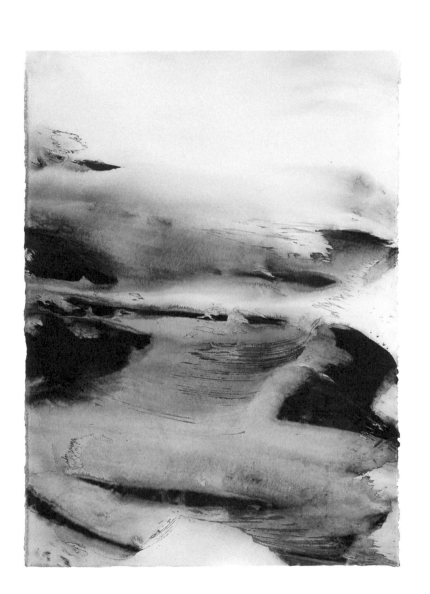

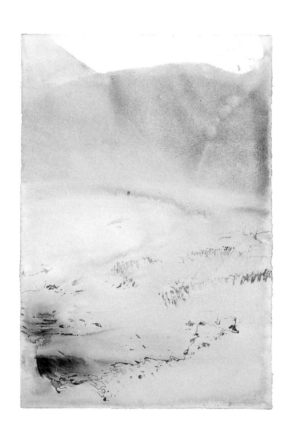

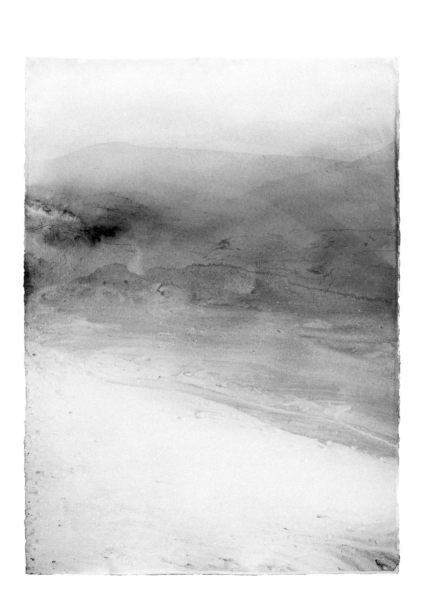

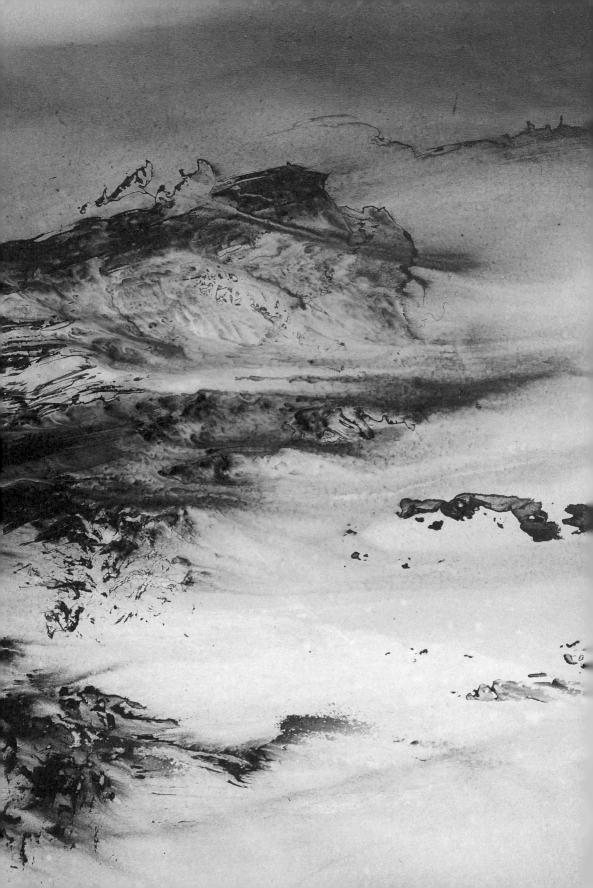

Werkliste
List of Works

SIMONE DISTLER

Lebt und arbeitet in Erdeborn

2015 – 2016	Graduiertenstipendium der Burg Giebichenstein Kunsthochschule Halle
2014 – 2016	Meisterschülerin von Prof. Ute Pleuger
2014	Anerkennung Kunstpreis 2014, Stiftung der Saalesparkasse Halle
2014	Diplom
2009 – 2014	Studium im Fachgebiet Malerei an der Burg Giebichenstein Kunsthochschule Halle, Klasse Prof. Ute Pleuger
2008 – 2009	Weiterbildung an der Haller Akademie der Künste, Schwäbisch Hall
2002 – 2008	Angestellt im Modevertrieb Authentic Style, Marktbreit
1999 – 2002	Ausbildung zur bekleidungstechnischen Assistentin und Modeschneiderin in Aschaffenburg
1982	Geboren in Dettelbach, Unterfranken

Lives and works in Erdeborn

2015 – 2016	*Post-graduate scholarship from the Burg Giebichenstein Kunsthochschule Halle*
2014 – 2016	*Member of the master class of Prof. Ute Pleuger*
2014	*Recognition Award in the 2014 Art Prize, Stiftung der Saalesparkasse Halle*
2014	*Diplom*
2009 – 2014	*Studied painting at Burg Giebichenstein Kunsthochschule Halle, Class of Prof. Ute Pleuger*
2008 – 2009	*Further training at Haller Akademie der Künste, Schwäbisch Hall*
2002 – 2008	*Employed in the fashion company Authentic Style, Marktbreit*
1999 – 2002	*Vocational training as a clothing technology assistant and fashion dressmaker in Aschaffenburg*
1982	*Born in Dettelbach, Lower Franconia*

Thomas Bauer-Friedrich

Studium der Kunstgeschichte und Germanistik an der Universität Leipzig; Magister Artium
zur Porträtmalerei des 18. Jahrhunderts

2002 Stiftung Bauhaus Dessau

2003 / 2004 Tom Blau Gallery, London

2004 – 2007 Museumsvolontariat bei den Kunstsammlungen Chemnitz

2007 – 2014 Kurator und künstlerischer Leiter des Museums Gunzenhauser der Kunstsammlungen Chemnitz

seit 2014 Direktor des Kunstmuseums Moritzburg Halle (Saale)

Publikationen zur Kunstgeschichte und Literatur des 18. bis 20. Jahrhunderts

Studied Art History and German Language and Literature at the University of Leipzig; Magister Artium,
Master's dissertation on 18th-century portrait painting

2002 *Stiftung Bauhaus Dessau*

2003 / 2004 *Tom Blau Gallery, London*

2004 – 2007 *Museum traineeship at Kunstsammlungen Chemnitz*

2007 – 2014 *Curator and Artistic Director of Museum Gunzenhauser der Kunstsammlungen Chemnitz*

since 2014 *Director of the Kunstmuseum Moritzburg Halle (Saale)*

Publications on Art History and Literature of the 18th – 20th centuries

Die Ostdeutsche Sparkassenstiftung, Kulturstiftung und Gemeinschaftswerk aller Sparkassen in Brandenburg, Mecklenburg-Vorpommern, Sachsen und Sachsen-Anhalt, steht für eine über den Tag hinausweisende Partnerschaft mit Künstlern und Kultureinrichtungen. Sie fördert, begleitet und ermöglicht künstlerische und kulturelle Vorhaben von Rang, die das Profil von vier ostdeutschen Bundesländern in der jeweiligen Region stärken.

The Ostdeutsche Sparkassenstiftung, East German Savings Banks Foundation, a cultural foundation and joint venture of all savings banks in Brandenburg, Mecklenburg-Western Pomerania, Saxony and Saxony-Anhalt, is committed to an enduring partnership with artists and cultural institutions. It supports, promotes and facilitates outstanding artistic and cultural projects that enhance the cultural profile of four East German federal states in their respective regions.

© 2017 Sandstein Verlag, Dresden | Herausgeber *Editor:* Ostdeutsche Sparkassenstiftung | Text *Text:* Thomas Bauer-Friedrich | Abbildungen *Photo credits:* S. 6, 10, 54 Gian Michael Merlevede, alle Werkfotos *all work images* Simone Distler | Übersetzung *Translation:* Geraldine Schuckelt, Dresden | Redaktion *Editing:* Dagmar Löttgen, Ostdeutsche Sparkassenstiftung | Gestaltung *Layout:* Simone Antonia Deutsch, Sandstein Verlag | Herstellung *Production:* Sandstein Verlag | Druck *Printing:* Stoba-Druck, Lampertswalde

www.sandstein-verlag.de
ISBN 978-3-95498-283-7